My blue Violin Method
Learning to play violin (acoustic or electric)
without tutoring or
learning how to read sheet music

© Marc Capuano

CONTENTS

Learning without tutoring
Choose a violin
The bow
The rosin
Bridge and strings
How to tune your violin and play in tune
How to hold the violin ?
How to read musical charts (tablature) for violin ?
First position
Diagram
First notes
Easy tunes
CONCLUSION

Learning without teacher

Learning the violin can be approached in different ways, the manner I am proposing here is inspired by my personal experience based on folk music. The apprenticeship of an instrument can be compared to the apprenticeship of a foreign language.
To start with, you learn words and expressions and you try to imitate the accents and the tone to be able to express yourself in this new language.
The violin being an instrument of expression, permits you to start in the same fashion.

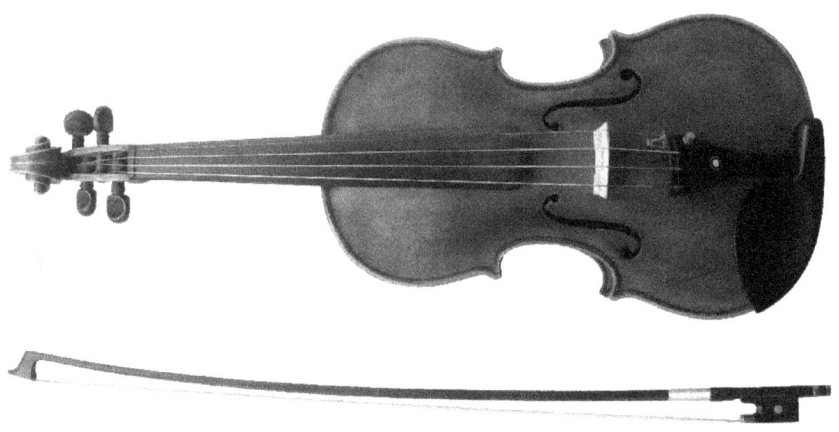

You will soon discover as with languages that there are accents, dialects and expressions specific to any region.
Inside any country, from one region or village to another, the voicing, accents and tones are different from one person to another. The same applies to the violin, to start with one tries to imitate like a child who is learning to speak with his parents, and eventually, naturally personalize ones own style and expressions.

This method consists in two main parts. The first part is dedicated to the discovering and function of the instrument. Secondly, a practical part with some chosen music. To be able to learn by oneself it's important to use a particular method for adaptive learning. In this book, you will find clues to help you autocorrect your playing, play the right notes and acquire a good basis on which to build your musical knowledge in the right conditions.

As with many instruments one can often get the sensation of being at a stand still after a certain time. This is natural, something like the growth of a tree that is not regular during the different seasons through the year (rain, temperature changes, etc).

When one gets this impression of a stand still, it is important to start something new, a new song or bringing out an old one not played for quite some time. Try playing with other musicians and record whenever possible enabling you to monitor your progress. You will discover things you didn't notice before, helping your progress.

Try fixing objectives for example learning 2 or 3 tunes that you could play at a party (birthday, wedding, …). There are so many different ways of playing without pretext, you can play in a street, in a bar and notice the ambiance it can produce. Pleasing a few people a few minutes can be an incentive to fine tune your playing and musical research.

I therefore wish you a good apprenticeship with this method and mostly a lot of pleasure

Choosing a violin

You will need an acoustic or electric violin with a bow. Violins made by well-known luthiers are relatively expensive. This price is due to the amount of work put in to build the instrument. If ever you have the occasion to go to Cremona in Italy (town of the famous luthier Stradivari), you may visit the Stradivarius Museum and the violin exposition at the « Palazzo Communale ». There you will see the amount of work necessary in the realization of a quality violin. You may also discover violins made by other world wide known luthiers (Amati, Guarneri).

To start with, there are industrially made violins new with bows, rosin in a hardcase for reasonable price. You will need in most cases to do a few adjustments, because of the price the bridges are often in the wrong place and the strings of poor quality.

It is possible to loan a violin and a bow but this implies insuring the instruments against accidents or theft. You may also buy a second hand instrument but one must be very careful because the person selling the instrument could give false information on the origin of the violin. As in art, there are many copies or forgeries. It's so easy to stick the label of a well-known luthier inside the violin and to age slightly the wood. It would be better to ask advice from an accomplished violinist or luthier enabling you to acquire a playable violin at a reasonable price. If you prefer an electric violin the choice will be simpler because the acoustic quality of the violin is less important and may be modified with the use of effect pedals.

Something about sound post :

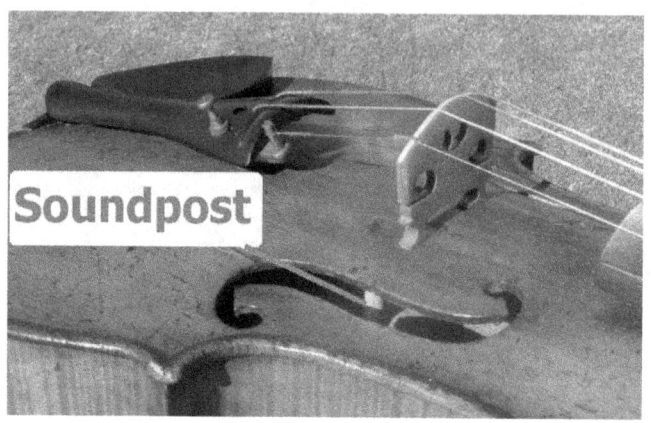

The sound post is a small piece of wood that transmits the vibrations of the top of the instrument to the back plate. It makes the violin tone much better and it prevents the belly from collapsing under the vertical component of the tension in the strings. This element restricts also the motion of the bridge treble foot.

As the bridge, the sound post is never glued, it is held in place by the pressure of the bridge and strings on the violin top. A slight knock will make the sound post fall if there is no string tension on the bridge.

If this little piece falls, you should ask a luthier to replace it because the position of the soundpost is a crucial component to the potential sound quality of your violin.

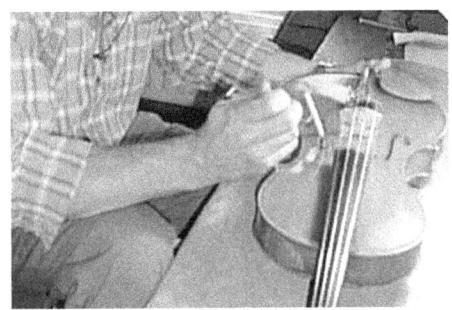

The sound post is directly under the treble foot of the bridge and about a quarter of an inch back towards the tailpiece.

On a 100% electric violin there is no sound post.

The advantage of an electric violin is that it permits you to play at a low volume meaning playing the instrument without bothering your neighbors.
In any case, always try the instrument for tone and confort before buying.

My Advice

It's no use buying a new expensive instrument, as you will hesitate to take it with you during your voyages. This goes against my advice because learning an instrument implies playing regularly, so will have to take your violin with you wherever you go.

The strings should not be too high on the neck, roughly between 3 millimeters on the E string and 5 millimeters on the G string.

Once you have been playing for a while, you will find it easier to choose an instrument to your taste. Always have your instrument and bow near you not in its case as the time lost taking it out is wasted.

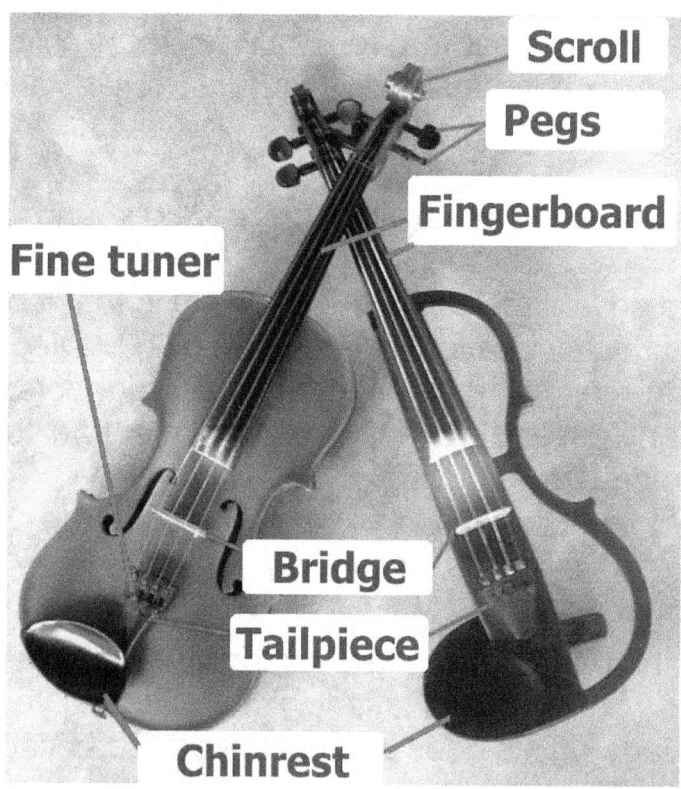

It is useful installing tail piece fine tuners making tuning easier.

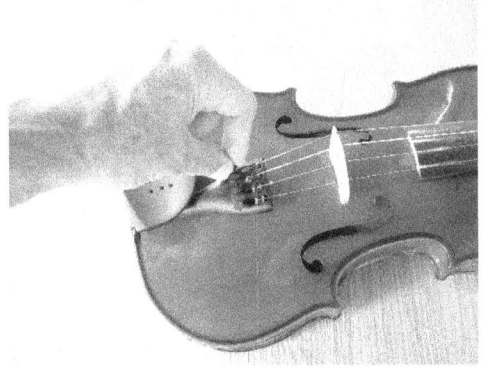

Violins may be found in different sizes 4/4 (full size), 3/4, 1/2, 1/4, 1/8, 1/10, 1/16.

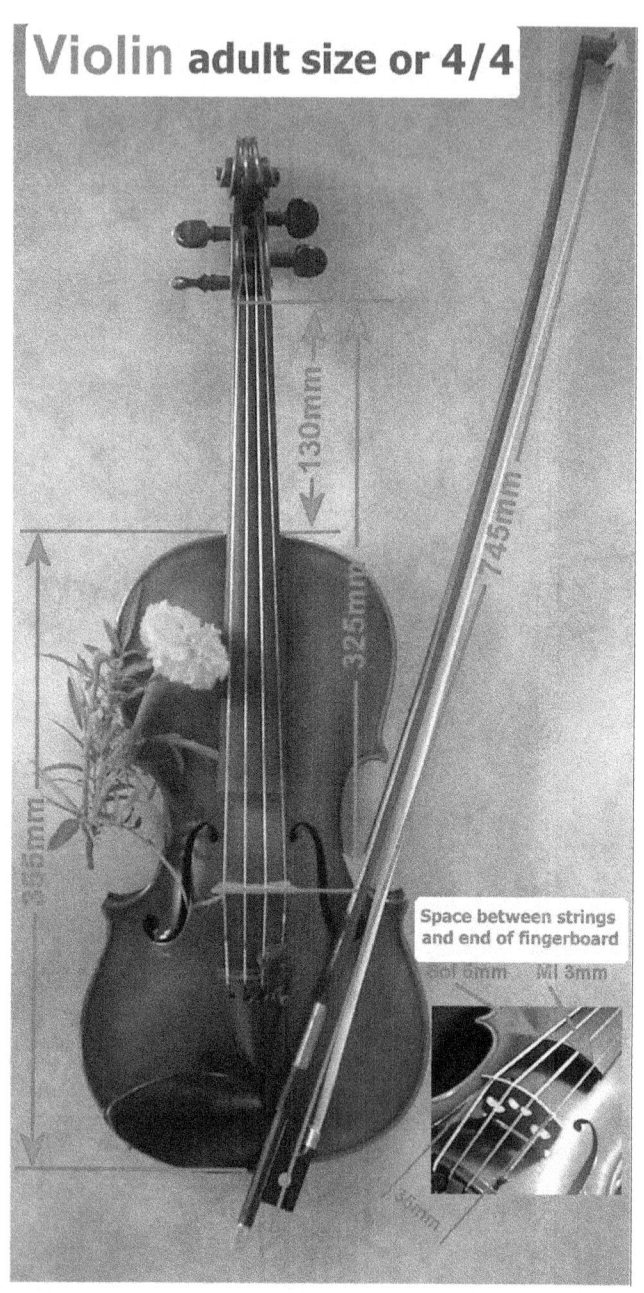

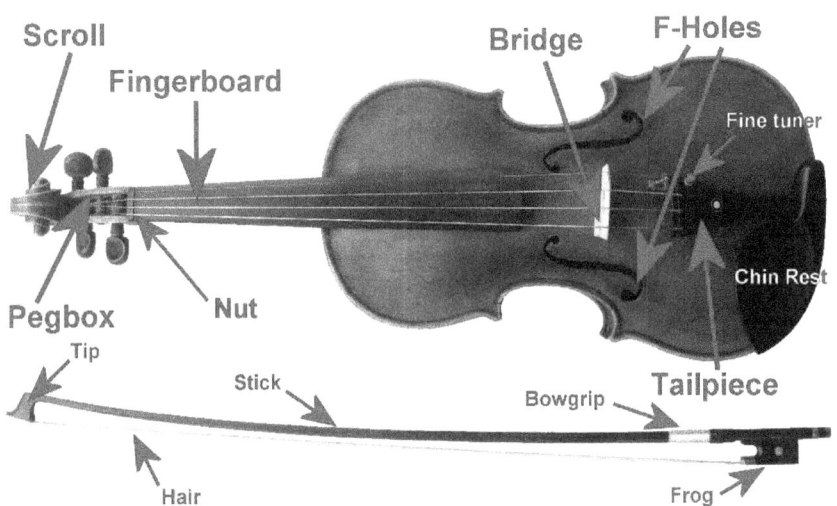

Choosing the correct size of a violin is done by holding the violin in the play position and verifying that you may correctly fold your wrist whilst playing near the nut without difficulty.

If you've never had a violin and you wish to order one of the correct size, measure the distance between your neck and your wrist with your arm stretched out sideways.

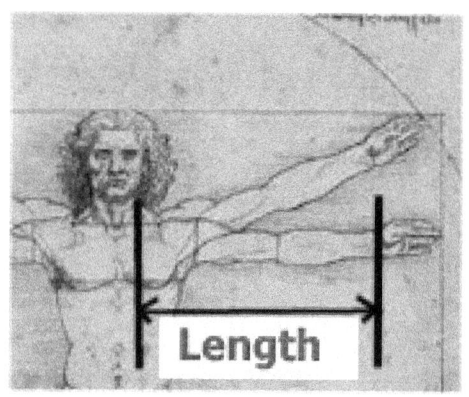

Length (neck to wrist)	Violin Size Body in mm	Age
580 mm	4/4 (full size) 355 mm	13 and more
550 mm	3/4 330 mm	10 -12 years old
510 mm	1/2 317 mm	8-9 years old

The bow

The bow is a stock made of wood or a composite material. The finest bows are made from pernambuco.

The bow wick is made of horsehair. These hairs are sorted and picked from horses with very long horsehair (Mongolian horses) which offer resistance and a certain elasticity. To adjust the tension of the wick you may tighten it using the screw at the end of the bow near the grip. Do not tighten it too much, there must also be a slight bend in the bow. The correct tension is reached when the wick is far enough away from the bow to prevent touching.

After use it is important to unwind the bow. Without this precaution the bow will become quickly unadjustable.

The wick should be changed once it becomes too thin. This should be done by a specialist although some bows exist with exchangeable wicks.

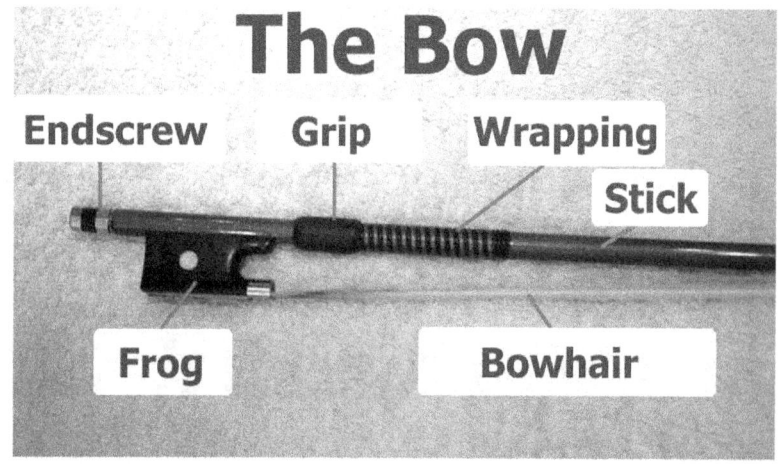

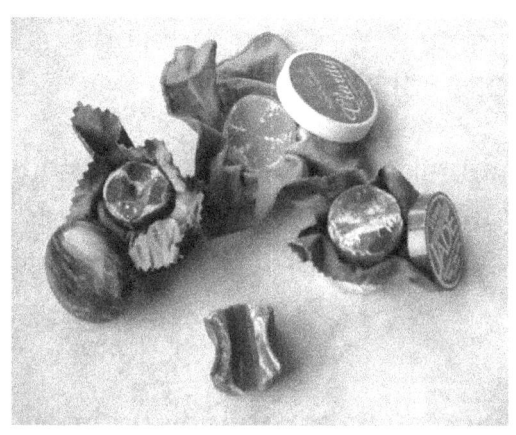

The rosin

The wick must be coated with rosin to enable the bow to vibrate the strings. Without rosin no sound is possible on the violin. When the bow is new or the wick has been changed it is impossible to get a note out of the strings because the wick slips on the strings without making them vibrate. Do not let this bother you it's normal.

If your cake of rosin is new you must first scratch the top with a metallic object (knife, key or file) to take off the fine crust. You may then coat the wick with rosin by slipping the rosin along the length of the wick as if playing the rosin cake.

If the bow is new one must brush the wick on the rosin cake several times before playing. If it still

does not sound good start coating again and repeat until a good sound is obtained.

Different qualities of rosin exist, when beginning it is easier to use a polyvalent rosin, you may then later test different qualities to obtain the sound you desire.

My advice :
After playing dust the strings and body of your violin with a soft clothe.

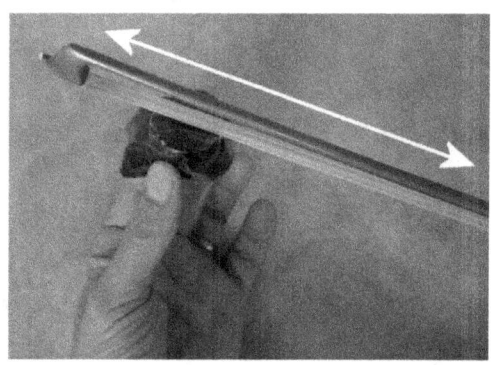

Bridge and strings

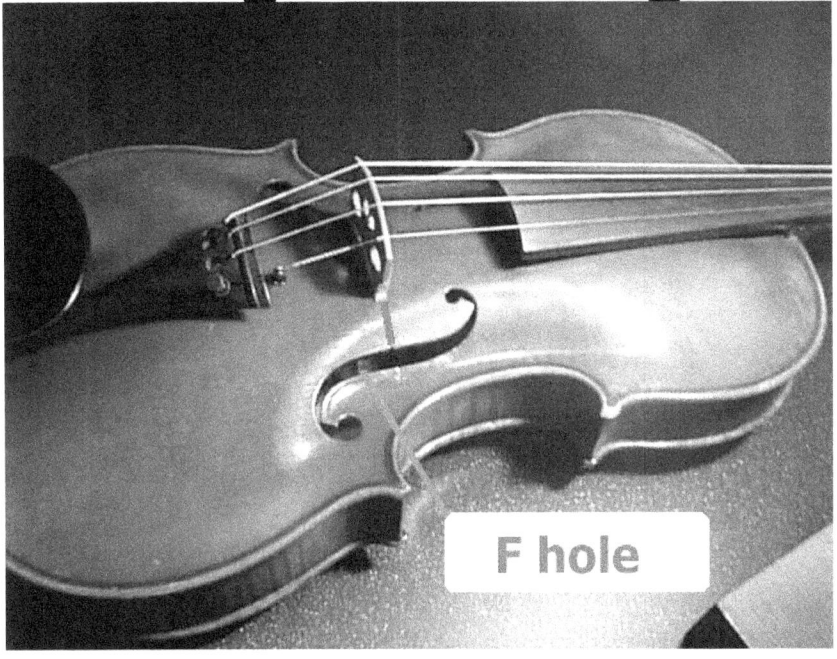

F hole

If the bridge is not in place it must be inserted under the strings by placing the higher side underneath the G string (the largest). To do this one must place the bridge under the strings with its base towards the middle of the F-holes. Then slowly bring it to a vertical position. Be careful to undo the tension of the strings a little so as not to break the bridge. It is important to retighten the strings progressively allowing you to place the bridge in the right position by slipping it back or to fro. Thus obtaining a well tuned instrument.

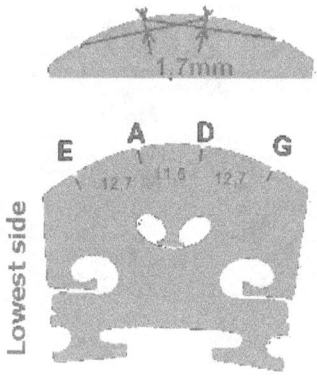

The bridge is a very important part of the violin because it holds the strings in the right place, if set incorrectly the instrument may become impossible to play. The strings are held in place by small slits. The curve on the top of the bridge allows the bow to play the strings one at a time. However, my advice is if you have difficulties putting the bridge in the right place consult a violinist or a luthier.

The strings are an essential element in the sound of the violin. They exist in numerous varieties and you will later discover that you may choose them according to the tone you want to obtain. The different types of strings can be made of natural gut (mutton), metal (steel, silver, gold, ...) or synthetic covered with metal. The gut strings are rarely used because they tend to easily get out of tune.

In order to not create any disturbance with your neighbors you may install a « practice mute » on the violin bridge. Rubber ones exist and are very effective. If you have to play a lot quieter it's better to use an electric violin (unplugged or with headphones).

How to tune your violin and play in tune

An electronic tuner is a very good tool to help correct fingering of the left hand.
It's better to choose an auto-chromatic tuner with led indicators showing all the notes of the scale.

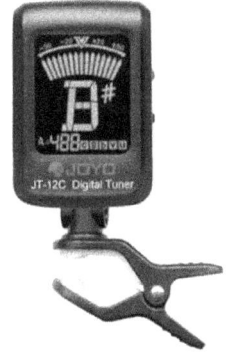

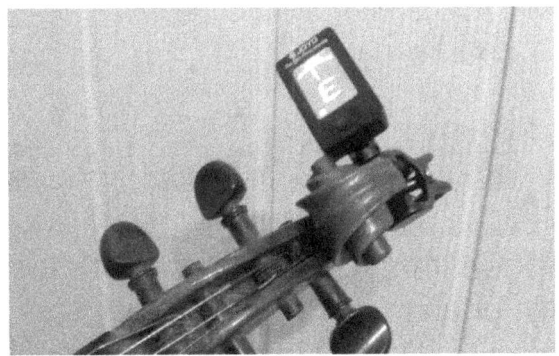

However, today it's possible to download free tuners onto a smartphone.

A tuner for guitar will do the job. It will also help you tune your instrument.

The four strings of the violin are (in order from the thinest to the largest) E, A, D, G. The A of the second string is at 440 Hz.

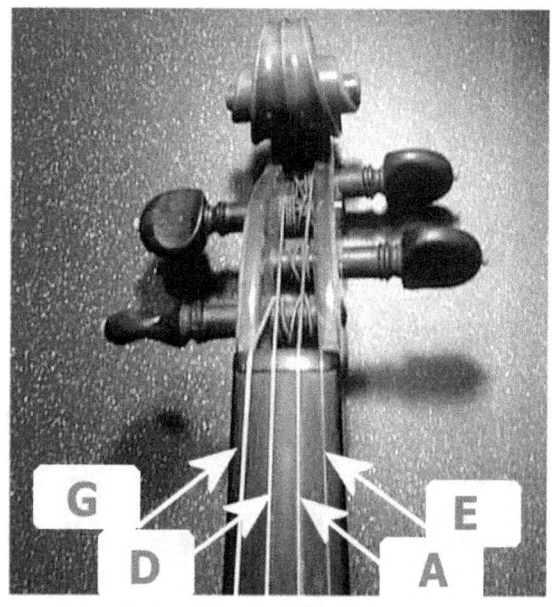

It's important that before playing your instrument is perfectly tuned.

Tune your violin

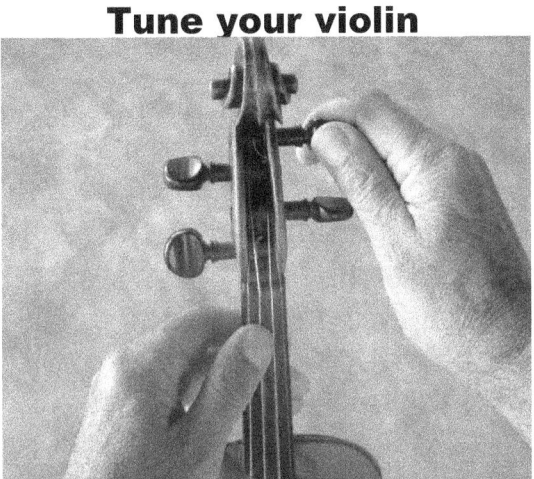

To tune your instrument you don't need the bow, you simply pluck the strings with your fingers.
After plucking while the string resonates verify the tuning on your tuner.
Be careful to have a good demonstration of how to use the tuner when buying.
If your violin is equipped with fine tuners, use these to correct the tuning perfectly.
The order to tune the strings is firstly the E string and finally the G string.
If you must change your strings at any time, change them one by one so as not to change drastically the pressure on the bridge.

My advice :
When tuning your violin for the first time undo the strings slightly, leaving enough tension for the strings to sound. Then, switch on your tuner and the strings one by one bringing up the tension until the correct note is attained.
When you start playing leave the tuner on, this permits you to verify the trueness of the notes played with the left hand.

How to hold the violin

You have probably noticed that violinists whatever the style but mainly in folk music never hold the violin in exactly the same position. But the important position is the most confortable position.

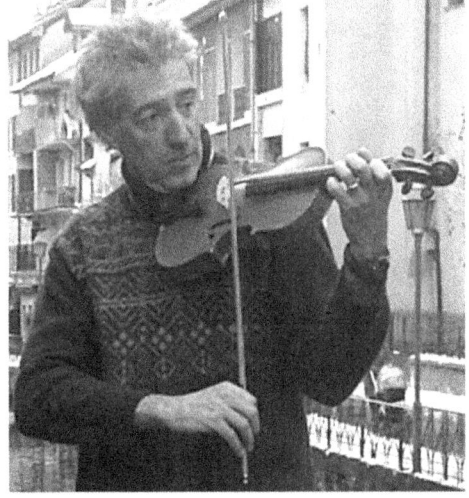

The violin is often inclined forward with the elbow of the fingering arm underneath the neck and the elbow of the bow arm along the body. In this position a few details are very important:
let out your stomach, this will redress the top of your body.
Breathe with your diaphragm, this will help to gain a better stability and facilitate your playing.

The violin is held between your neck and your collar bone.

Well wedged against the neck, try to find the most comfortable position without your instrument being in direct contact to the skin. To achieve this one can use a cloth of some kind. The fingers of the fingering hand must be able to move freely and not be used to maintain the instrument in position.

A) The fingering hand

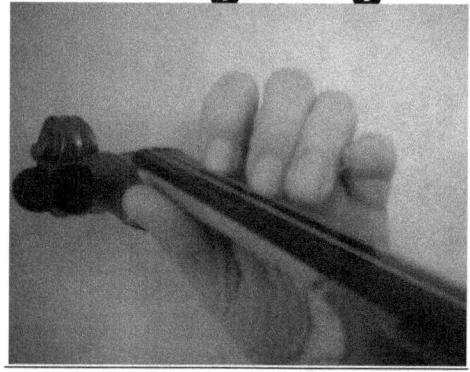

Nails should cut short.
1) The palm of the hand does not touch the neck and the wrist is aligned with the forearm.
2) The fingers are curved perpendicularly to the fingerboard.
3) The thumb is not posed on the back of the neck but slightly to the interior.

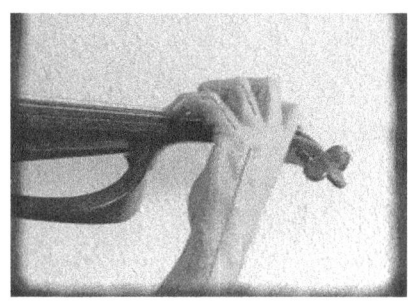

B) The bow hand

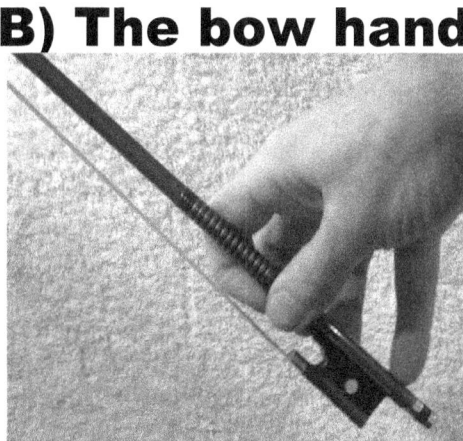

The bow hand holds the bow above the frog, the thumb against the pad, the middle phalanx of the index is against the stick on the winding, this enables you to add pressure to the strings. The little finger is placed toward the screw enabling you to reduce the pressure of the bow on the strings. The bow should be drawn straight, and perpendicular to the strings.

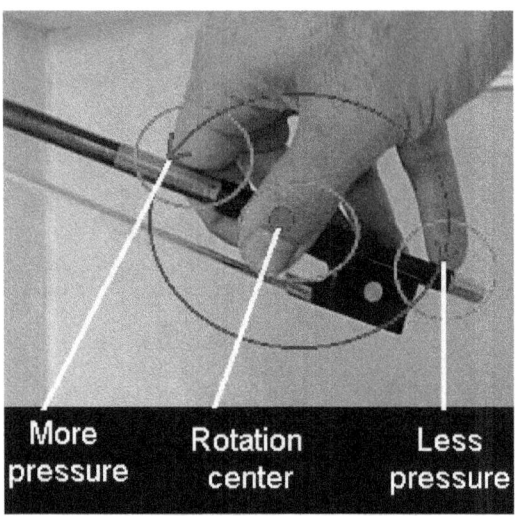

In the beginning the bow hair should only touch one string at a time when changing strings the bow is inclined by raising or lowering the bow hand.

The pressure of the bow on the strings is not constant : when pulling the bow downwards, one should gradually increase the pressure. When pushing the bow upwards, the pressure on the strings should gradually decrease.
The bow should not drift from bridge to fingerboard but stay at an equal distance between the two.

Now take your bow and violin and try playing on one open string by pulling and pushing the bow along its entire length. Try this several times on every string.

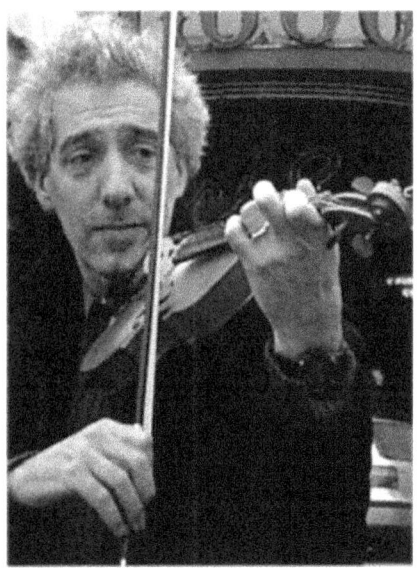

How to read a musical chart (tablatures) for violin

The tablature is a very old form of written musical chart. One of the many advantages of the tablature system is that it gives you a visual approach to reading music giving the exact fingering.

In this method you will find the melodies written in tablature form for violin, as it was written during the baroque era. Today, many violinists prefer this kind of notation, often using original manuscripts or printed with computer programs like « Guitar Pro ».

The violin has 4 strings :
The first (the thinnest) is the E string
The second (slightly larger) is the A string
The third the D string
The fourth (the thickest) is the G string
These strings are represented on a tablature by 4 horizontal lines, the top line being the E string.

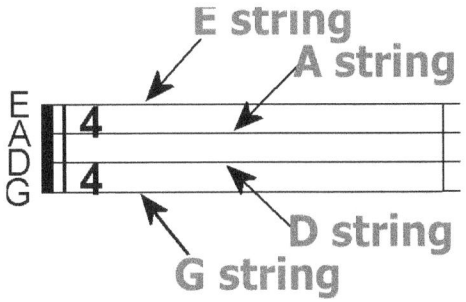

Here is a tablature with notes to play:

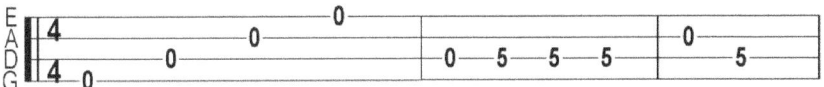

The figures written on the horizontal lines correspond not only to the notes but also to the fingering.

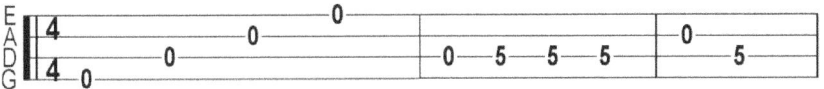

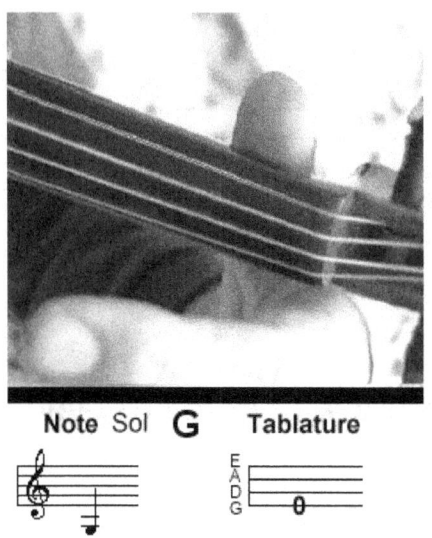

When the figure zero appears (see picture above) on the tab this signifies the strings should be played open.
The tab is always read from left to right.

This tab (see picture below) shows the number 5 on the D line, this means one should placed a finger on the D string in the 5th place.

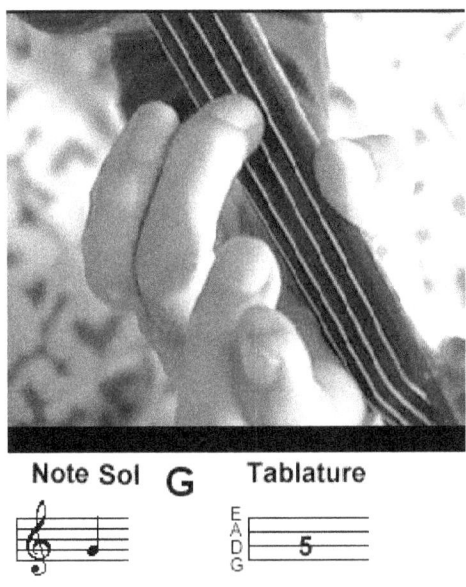

First position

Most music for violin is written with the hand in the first position, where the hand remains close to the scroll end of the fingerboard.

Each finger of the fingering hand has two places and two notes, the index places number 1 and 2, the middle finger places 3 and 4, etc.

In the first tablature studied the finger used is indicated by a number :
Number 1 for the index, number 2 for the middle finger, number 3 for the ring finger and number 4 for the little finger.

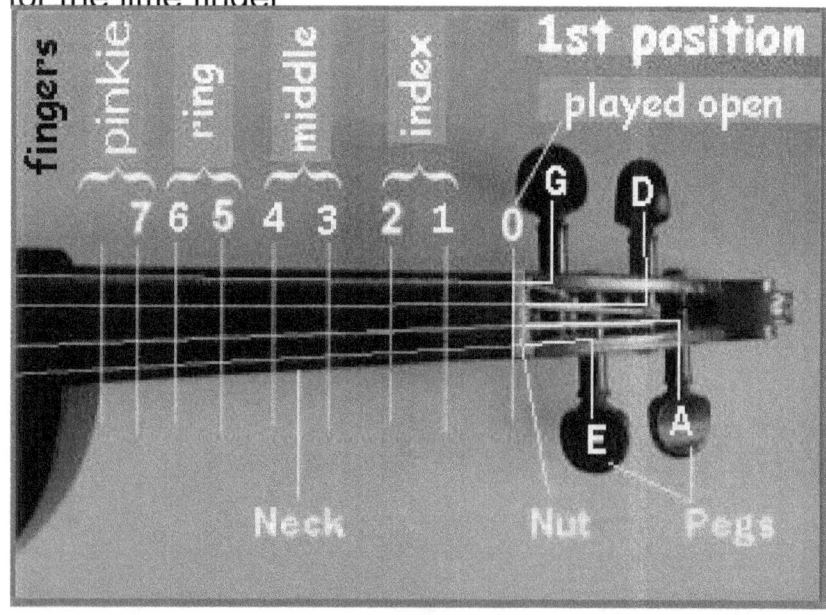

We may now try playing some notes with the three first fingers.

1) Index finger

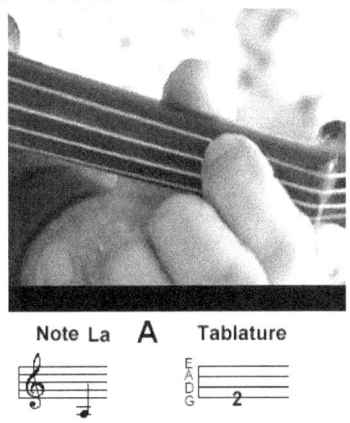

Note La A Tablature

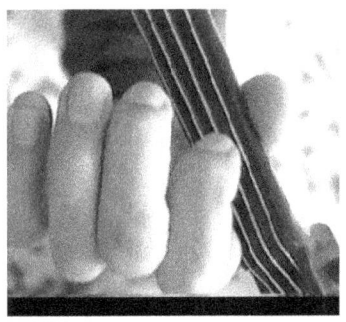

Note Mi E Tablature

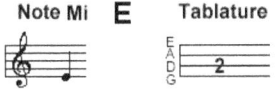

2) Middle finger :

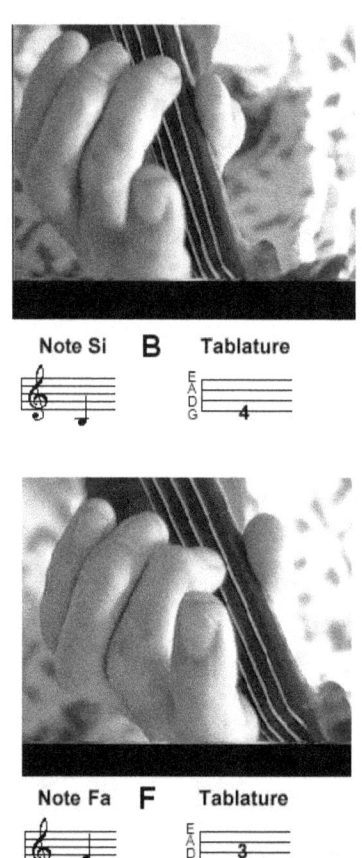

Note Si **B** Tablature — 4

Note Fa **F** Tablature — 3

3) Ring finger :

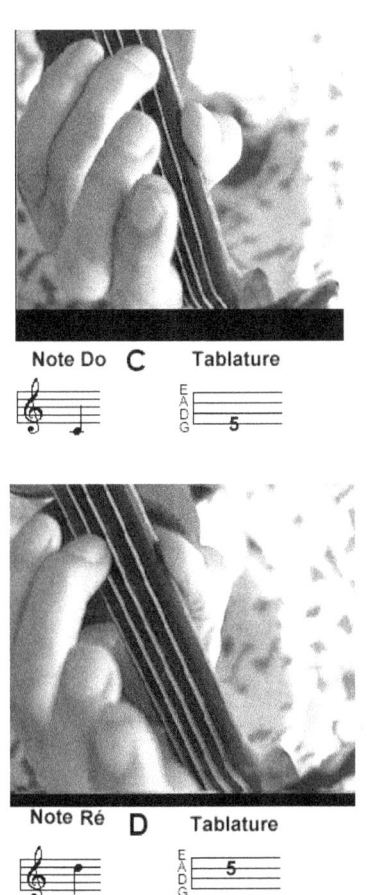

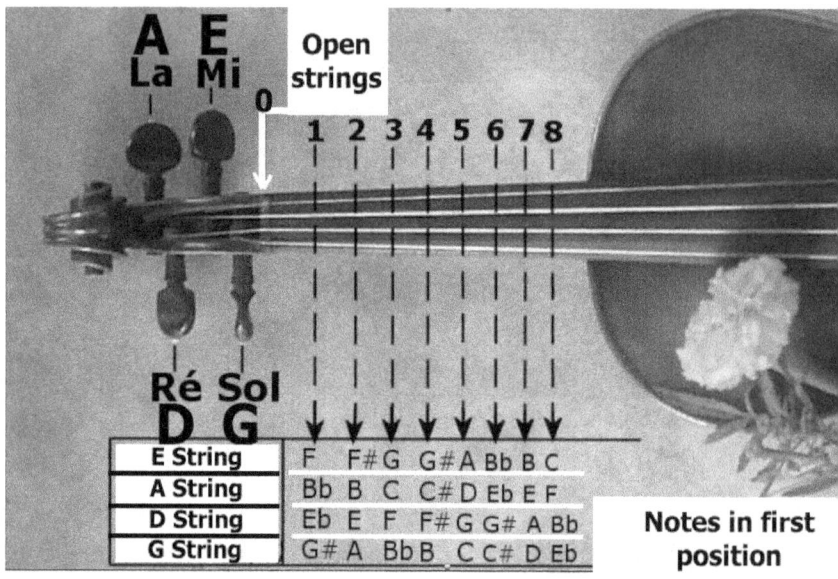

Notes in first position

In this last picture are shown, the locations and associated notes on the fingerboard.

On the G string (the thickest) you obtain the notes: G sharp (G#) in place 1 with the index, A in place 2 again with the index, B flat (Bb) in place 3 with the middle finger ...

One must use the index for places 1 and 2, the middle finger for places 3 and 4, the ring finger for places 5 and 6 and the little finger for place 7.

One must pay attention to not touching the neck with the palm of the hand in the first position.

Diagram

The location of the fingers on the fingerboard may also be shown on a diagram representing frets as on a mandolin or guitar.
You may copy the following diagram on paper whilst strictly respecting the dimensions shown. Then, place it under the violin strings.
These dimensions are approximate and valid for adult size violins only.
One may check the fret positions with an electronic tuner once the paper is in place.
For smaller violins, one must reduce the dimensions of the diagram using an auto-chromatic tuner.

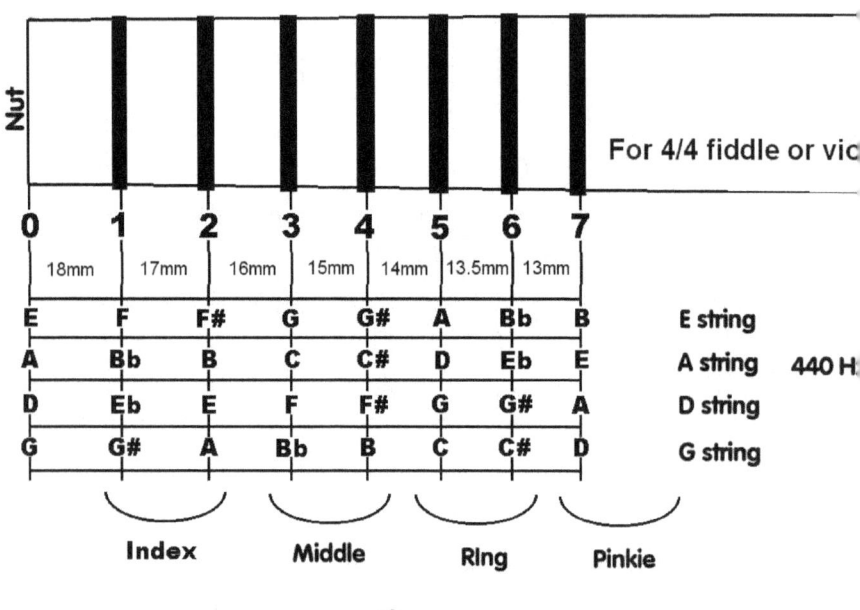

On the following pictures are shown the steps of the set up on the fingerboard.
It's possible to learn to play with the paper on the fingerboard but if used I recommend not using it for too long a time. Because one may get into a habit of looking at the notes instead of listening.
One must listen to the notes produced in the correct finger positions, if possible using an auto-chromatic tuner to check that it's in tune.

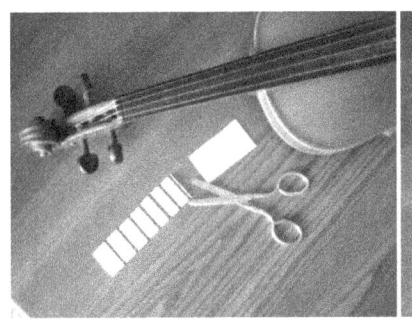
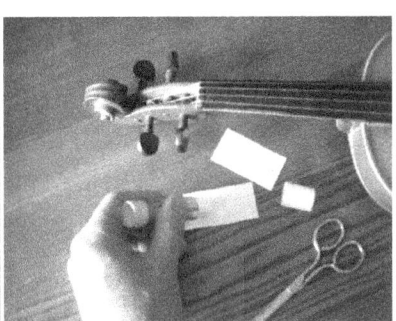
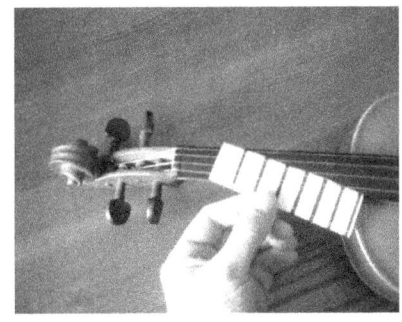
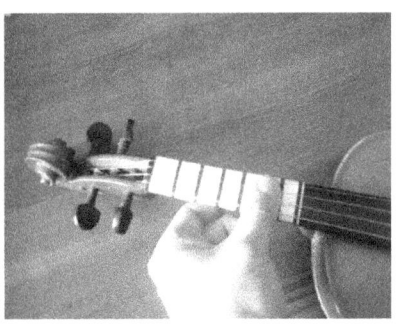
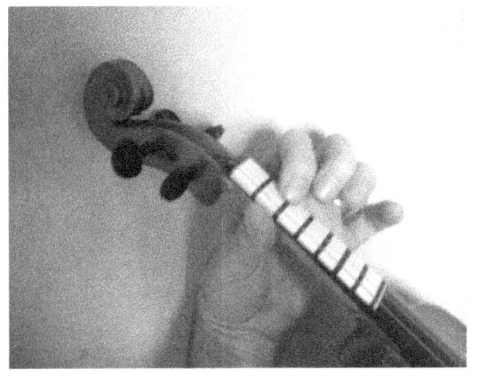

My advice:
When playing on the D string with the ring finger in the 5th place one should produce a G note. This should provoke a resonance with the G string. If this doesn't happen it means the note played isn't in tune. Check with a chromatic tuner.

First notes

Take your tuned violin with bow hair slightly stretched and coated with rosin. Even though you have already tried to play it's not important. Place the violin between your collarbone and chin. Place the bow on the fourth string (G string) in a perpendicular position using a mirror to check.

Exercise 1 : Without using your fingers just play on one open string pushing and pulling the bow whilst keeping an eye on the angle made by the bow throughout the movement. The note obtained should be as stable as possible. Use the full length of the bow.
One will notice the difficulty in obtaining a stable note throughout the full length of the bow. This is normal, relax, don't hold your breath, expire breathing slowly. Try this exercise on each string. Dosing the pressure on the bow decreasing it when approaching the frog and increasing it towards the tip.
Use this tab :

```
||4-------0--0-------|
||    -0-----  -0----|
||4-0-----------0----|
||4-0-------------0--|
```

Exercise 2 : Now place the bow on two strings at a time. It's important that the wick touches both strings equally.

Now, do the same exercise as before pulling and pushing the bow whilst playing both strings, this is called « double stop ». You should hear two notes distinctively.

Exercise 3 : Now do both exercises randomly, playing single and double notes, feeling the position of the bow across the strings. For example

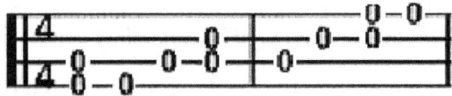

We now know how to play violin on open strings, we will now learn to play using the fingering hand obtain additional notes.
Exercise 4, with the index finger : Let's now a little exercise for the first finger, do this exercise very slowly in executing each note and check the tune with auto-chromatic tuner.

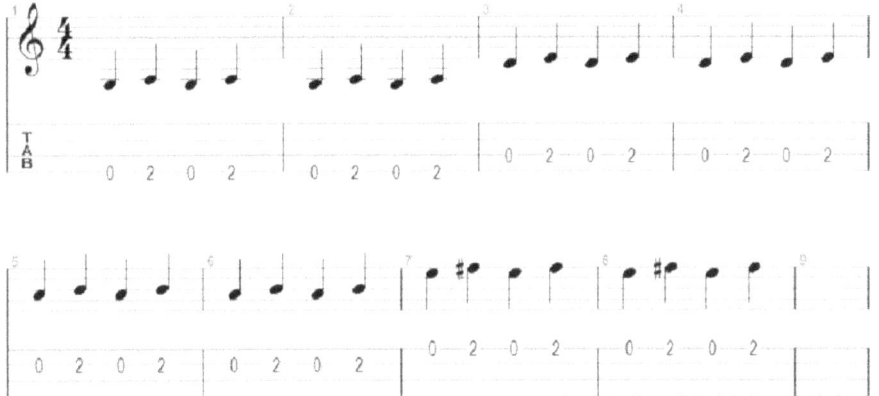

Let's now try a little exercise using the first finger. Do this exercise slowly checking the notes with an auto chromatic tuner.
[Tab]
In the above tablature you will notice that the notes are written in two different formats ut I recommend following the tablature to get your fingering right.

In the eight first notes you will notice the number 2 on the G string, this means putting your index finger in place number 2. If you look back at the diagram you will notice that the note played is A.

So when you see 0 you play an open string, when you see 2 you play an A with the index.

After this exercise, try it again on the other strings obtaining an E on the D string, a B on the A string and an F# on the E string.

Exercise 5, the ring finger

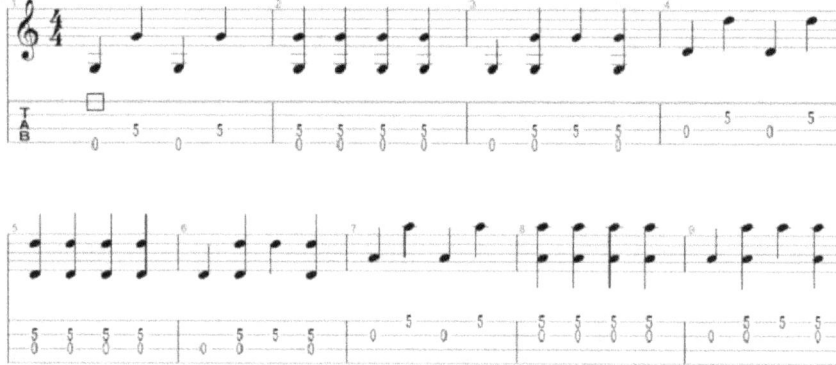

In this exercise you will bow sometimes in double-stop and use the ring finger. This finger is very important because you will play it in place number 5. The notes played on the three upper strings D, A and the highest E are played as follows. For example, if you play a G note on the D string it is the same name as the string below. If you play the note with your ring finger in place number 5 you will hear that the note is wider and richer because the G string will vibrate as well if your note is perfectly in tune. You must remember that this is very important and will be a great help in finding place number 5 on the fingerboard.

Exercise 6, two fingers

Now that we have exercised the index and the ring finger, one after the other, we will now do an exercise that uses both fingers. To be sure that you control the bow properly do this exercise in front of a mirror paying attention how you hold the violin, that the palm of your left hand does not touch the neck and that the bow moves perpendicularly to the strings.

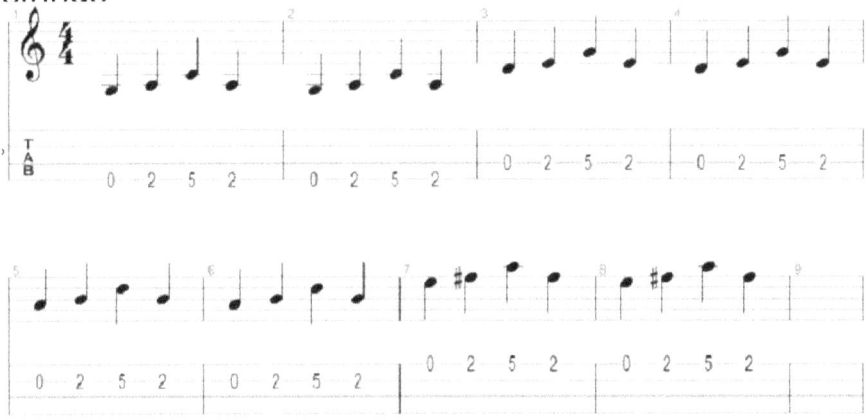

Easy tunes

The first melody we are going to learn is the well known song « Happy Birthday ».
Having already heard this song it will be easier to find the notes on the fingerboard.
Take the diagram showing the finger places 2 and 5 on the D string.
To facilitate learning the melody it is divided into four parts.

Happy Birthday

part 1

| 0 | 0 | 2 | 0 | 5 | 4 |

part 2

| 0 | 0 | 2 | 0 | 0 | 5 |

part 3

| 0 | 0 | 5 | 2 | 5 | 4 | 2 |

part 4

| 3 | 3 | 2 | 5 | 0 | 5 |

Starting with part 1. The first two notes are played on the open D string, no difficulty here.
Then for the third note, we place the index on the same string in position number 2 giving the note E.
For the forth note, release the string thus playing the open D string again.
The fifth note is played on the same string in position number 5 thus giving a G.
The last note in part 1 is played with the middle finger in position number 4 giving an F sharp or an F#.
You have now played the six notes of part 1, you should now try to play this six notes a dozen times being careful to maintain the position of the violin as indicated previously.
Use an auto-chromatic tuner to check the notes you play. After playing these notes several times you should begin to recognize the melody of « Happy Birthday ». You can then go on to the following parts.

You must then imperatively in every family birthday occasions play this song thus helping you work out and refine your technic. Even more, find someone who plays another instruments (piano or guitar) using the chords as indicated below.

 G D
Happy birthday to you
 D G
Happy birthday to you Mary
 G C
Happy birthday to you Mary
 C G G
Happy birthday to you

The letters G, D, C, above the lyrics are the chords which should be played by the other musician who accompanies you.

Our next song is a country song called « Oh Susanna ».
This easy and very well known tune must also be studied in several parts.
The placement of the fingers and the direction of the bow are indicated in the tablature.
The fingers of the left hand and the direction of movement of the bow are indicated in the tablature.

Oh Susanna

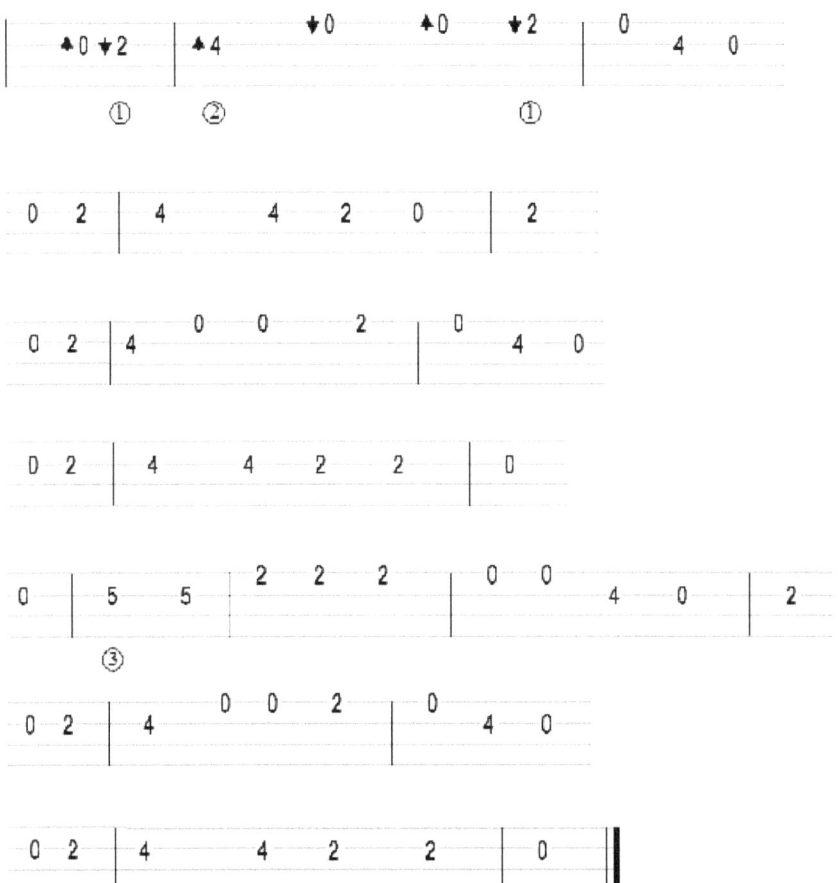

Once you have succeeded in playing the parts without looking at the tablature pay attention to your rhythm, it must be regular throughout the tune.

Here are the chords on the lyrics to accompany the song.

```
        A                                    E
Well I come from Alabama with my banjo on my knee
        A              E           A
And I´m goin´to Louisiana.my true love for to see
 D           A            E
Oh,Susanna,oh don´t you cry for me,
        A                  E            A
I´ve come from Alabama for my true love for to see
```

The next tune is a gospel song "Oh when the saints go marching in"

When the Saints go marching in

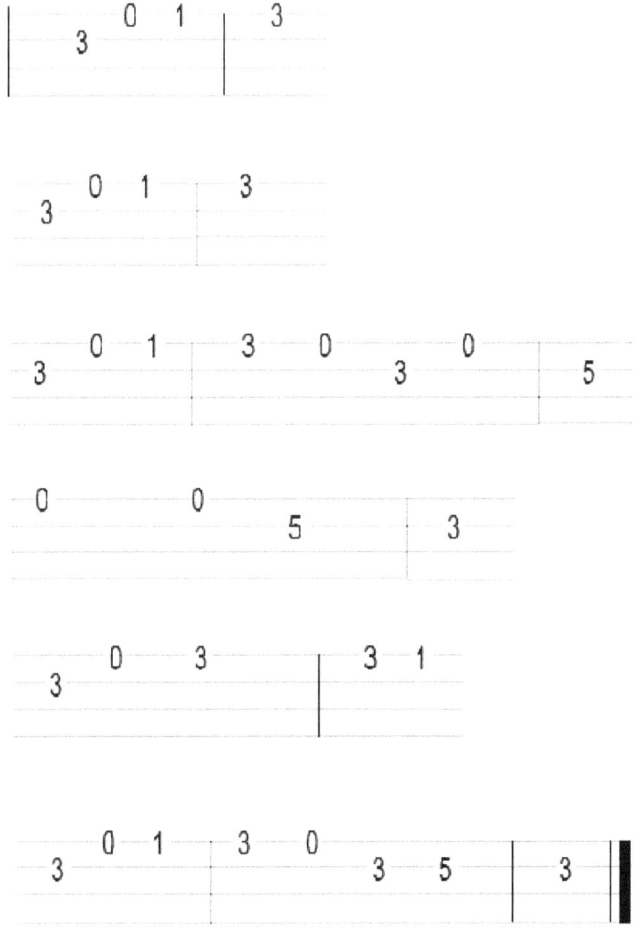

Another easy tune to play

Skip to my lou
Traditionnel

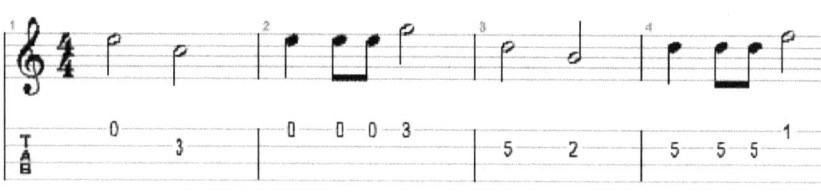

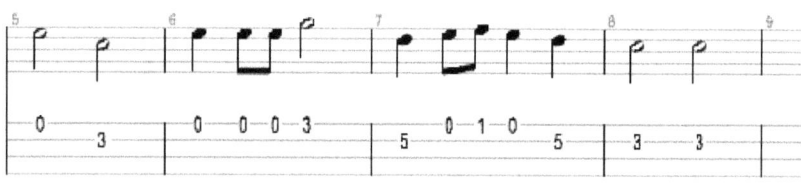

Now a easy classical tune Pachelbel the famous Canon in D :

Canon en Ré de Pachelbel

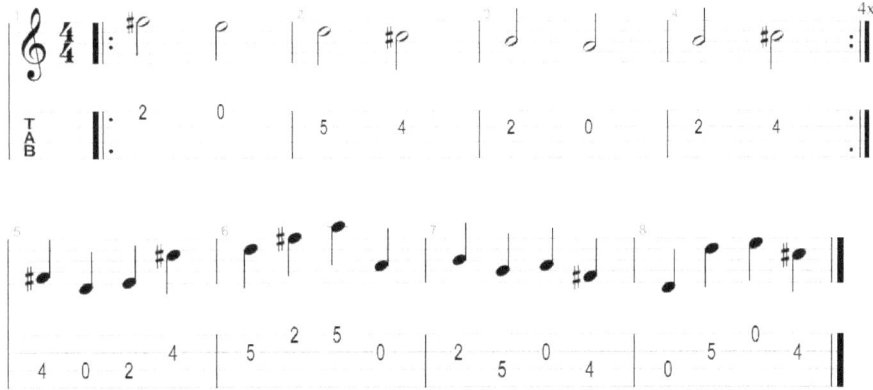

Or silent night :

Silent Night
Douce nuit

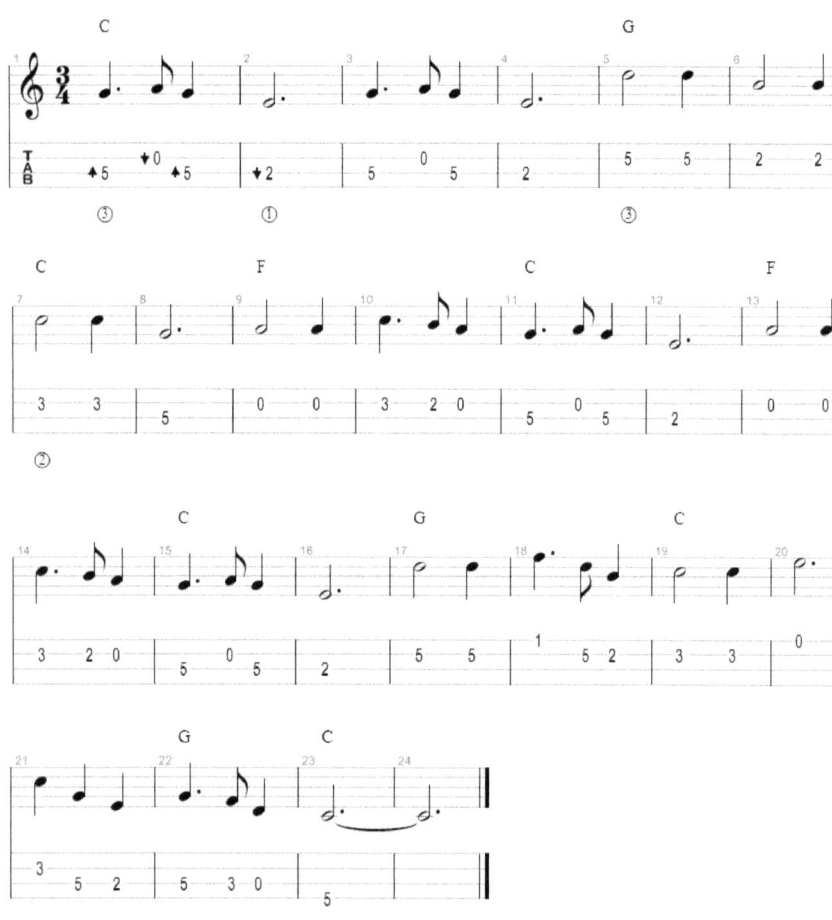

Now the best symphony of Beethoven :

9ème Symphonie de Beethoven

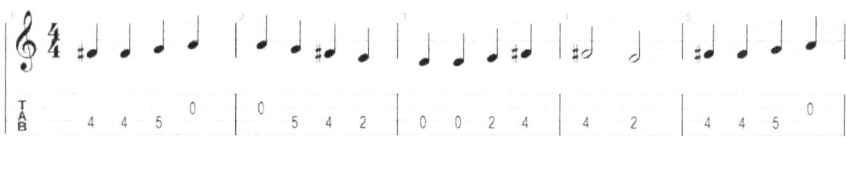

An irish tune :

Swallowtail Jig

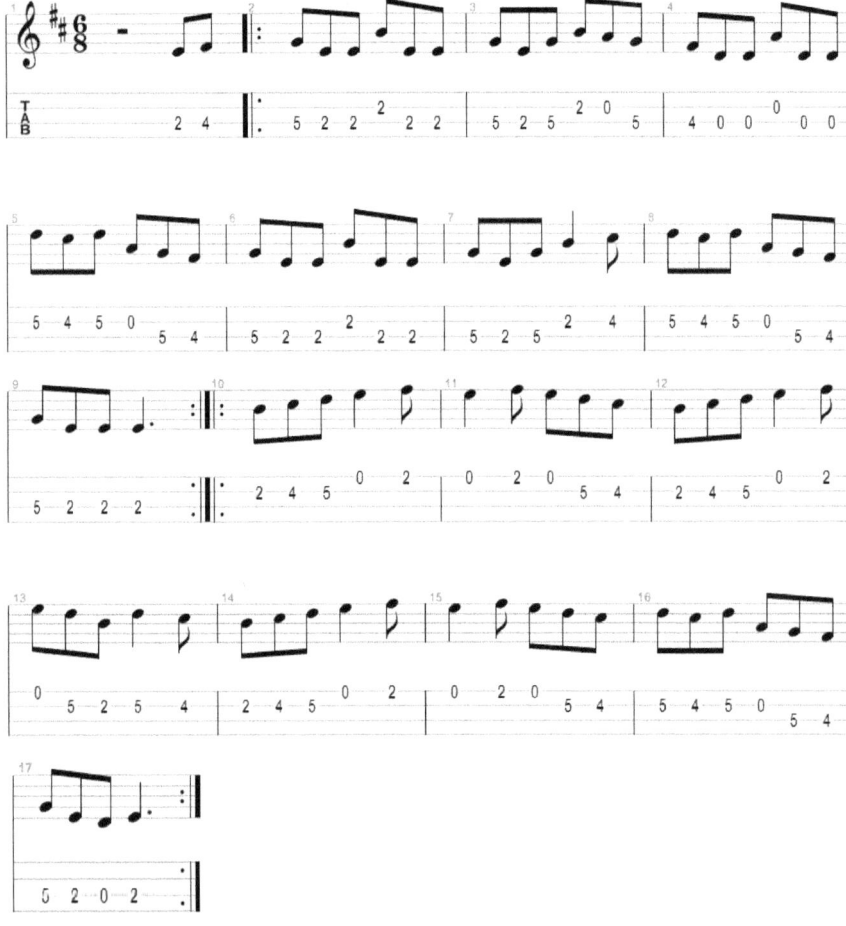

And an italian song :

Bella Ciao

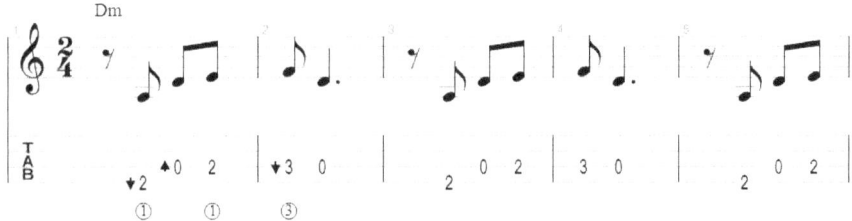

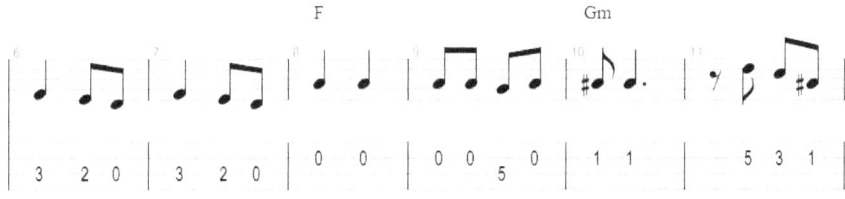

CONCLUSION

Once you have arrived here and followed all the advice given previously you probably realize that you can learn to play violin on your own without reading music. Also that you are able to play a few songs, it is important to play these song everyday for at least an hour.
If you exercise everyday you will see that in a few months your movement will become more precise and relaxed. Keep in mind to regularly check the tuning of your notes with an auto-chromatic tuner while playing very slowly.
If a problem occurs, do not ignore it, try to find the source of the problem, be it the speed, the tuning or the rhythm ...
Once the problem is found, try working on it slowly whilst checking the violin's position, try to overcome the problem by using the technic in another context, repeat again, let in it grow, and you will realize with time that this works.

I hope that you will obtain a lot of pleasure with your new friend The Violin !

Marc Capuano

http://www.violonbleu.fr

https://www.facebook.com/leviolonbleu/

www.ingramcontent.com/pod-product-compliance
Lightning Source LLC
Chambersburg PA
CBHW070432180526
45158CB00017B/980